COLOR TIPS

As a designer, I love to experiment with colors and to mix technique[s]/mediums. For me, bright and bold always looks good. Sometimes I like all [warm] colors and sometimes all cool colors. Other times I randomly mix warm and cool colors together in the same design, creating a bold complementary palette.

Check out the handy color wheel below. Each color is labeled with a P (primary), S (secondary), or T (tertiary). In the very center of the wheel, you'll see a circle of lighter colors, called tints. A tint is a color plus white. On the outer edges of the wheel, you'll see a ring of darker colors, called shades. A shade is a color plus black. The colors on the top half of the color wheel are considered warm colors (red, yellow, and orange), and the colors on the bottom half are called cool (green, blue, and purple). Colors opposite one another on the color wheel are called complementary, and colors that are next to each other are called analogous. Experiment with color yourself with this quick reference page to serve as inspiration!

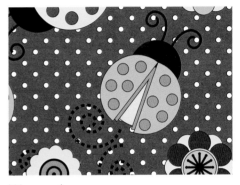

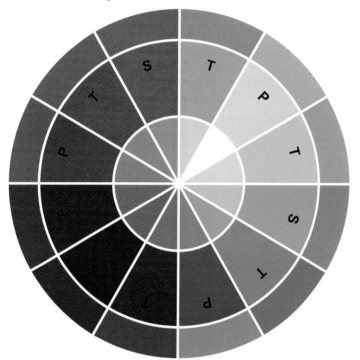

Cool colors

Warm colors

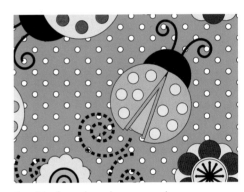

A mix of cool and warm colors

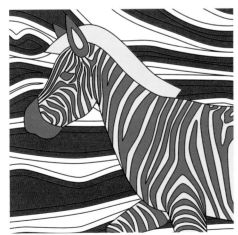

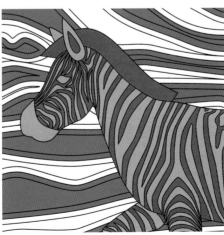

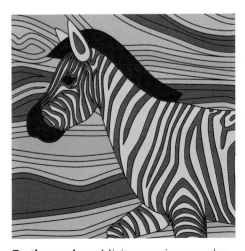

Primary colors: The primary colors are red, yellow, and blue. They are called "primary" because they can't be created by mixing other colors.

Secondary colors: Mixing primary colors together creates the secondary colors orange, green, and purple (violet).

Tertiary colors: Mixing a primary color and a secondary color together creates the tertiary colors yellow-orange, yellow-green, blue-green, blue-purple, red-purple, and red-orange.

1

Color Ideas

The stylized creatures in this book can be colored in many different ways. For example, you can use an all cool or all warm color scheme, or go wild with a multicolor palette. Check out the samples on this page for ideas.

Remember, there are no right or wrong ways to color these designs. This book was created for your enjoyment. As you are coloring, take your time, relax, and enjoy the creative and meditative experience. Each page is filled with details and forms you can choose to color in a variety of ways. Try a bright and bold color palette with solids on one page, then try a soft, pastel scheme with shading and gradients on another page. You will be amazed at the variety of results!

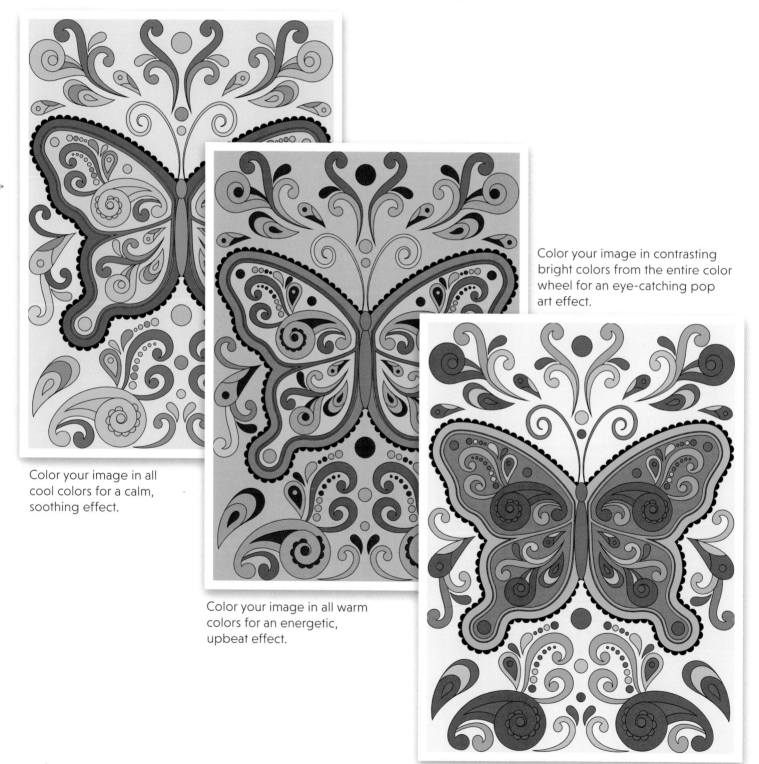

Color your image in contrasting bright colors from the entire color wheel for an eye-catching pop art effect.

Color your image in all cool colors for a calm, soothing effect.

Color your image in all warm colors for an energetic, upbeat effect.

COLOR LAYERING

As shown in the design below, it is best to start with the lightest colors first—in this case, shades of light blue for the background. Then add the darkest background color, such as the aqua blue shown. In this color sample, the next step is to add the lightest green elements to the main image. As a last step, you can add the darkest colors to the main image to make it pop out and have sharp contrast from the background. Feel free to add gradations to your color fills for a softer look or use all solid color fills for a bolder effect.

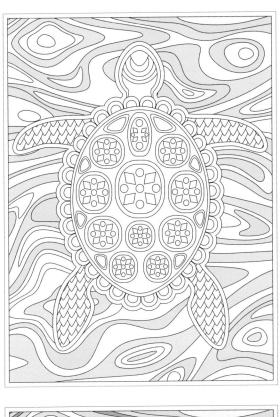
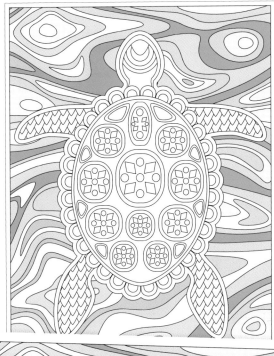
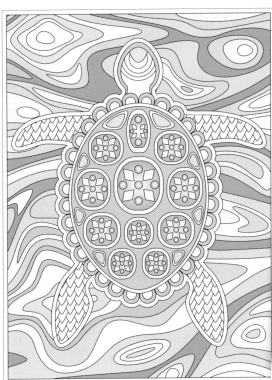
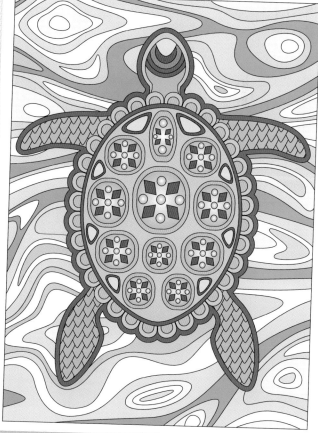

COLOR INSPIRATION

The following pages are filled with colored samples to get you thinking and imagining. First, you'll find pages full of multiple color ideas for single images, so you can see how a different color scheme and approach can make the same design look radically different. Then, you'll find several gorgeous hand-colored pieces using a variety of different art mediums by different talented colorists. Enjoy the colorful inspiration here before you sit down to create beautiful art yourself—let your creativity flow!

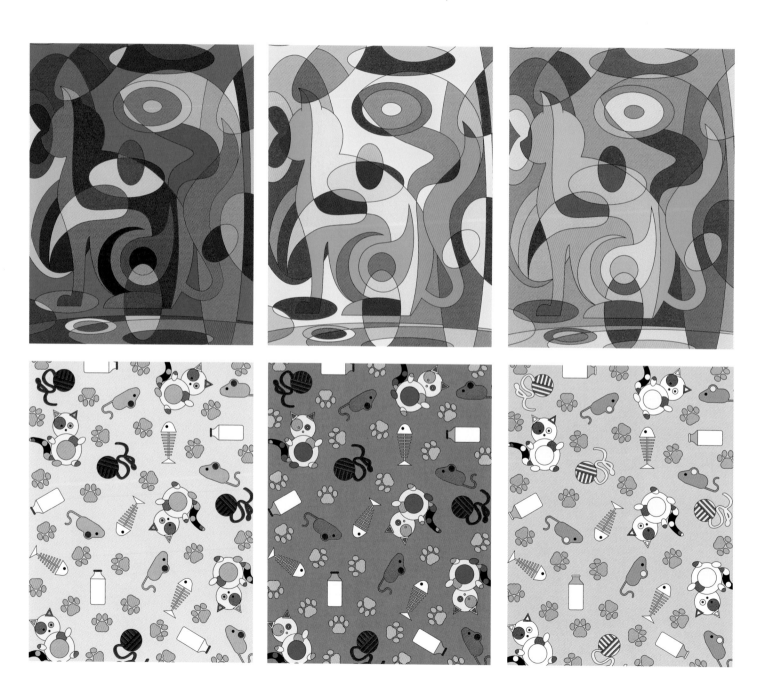

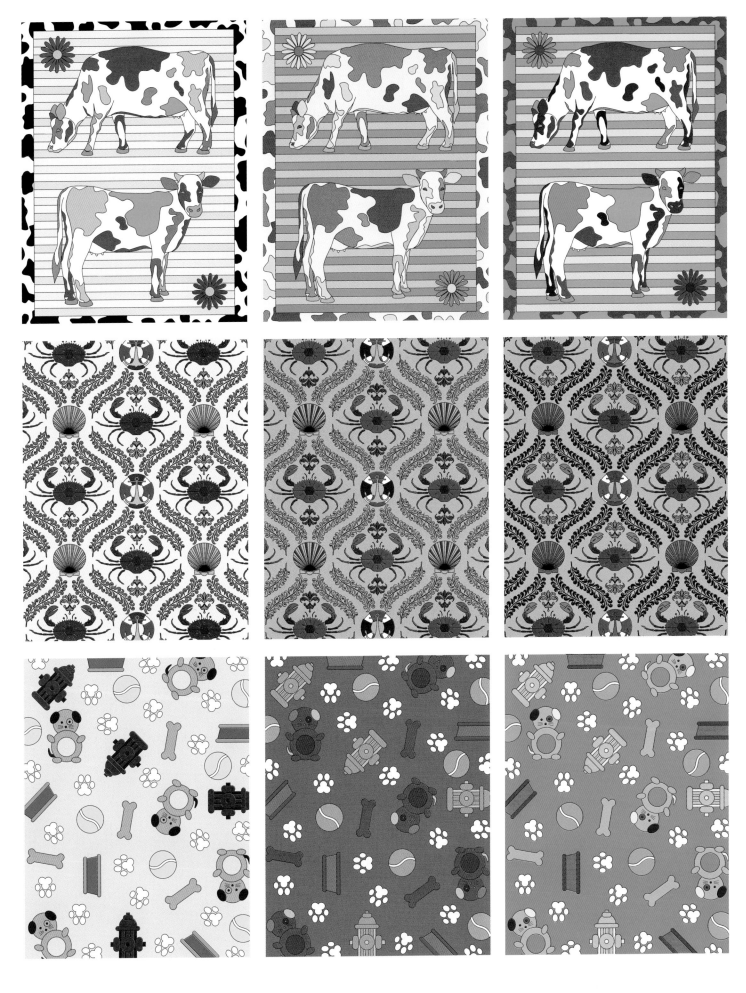

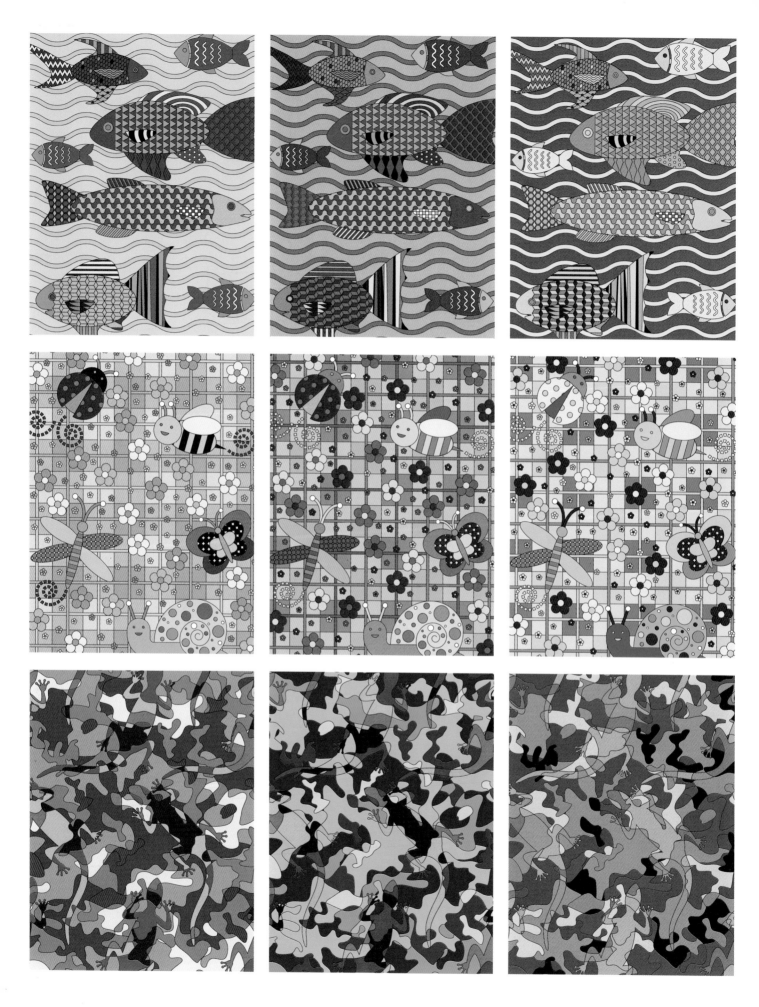

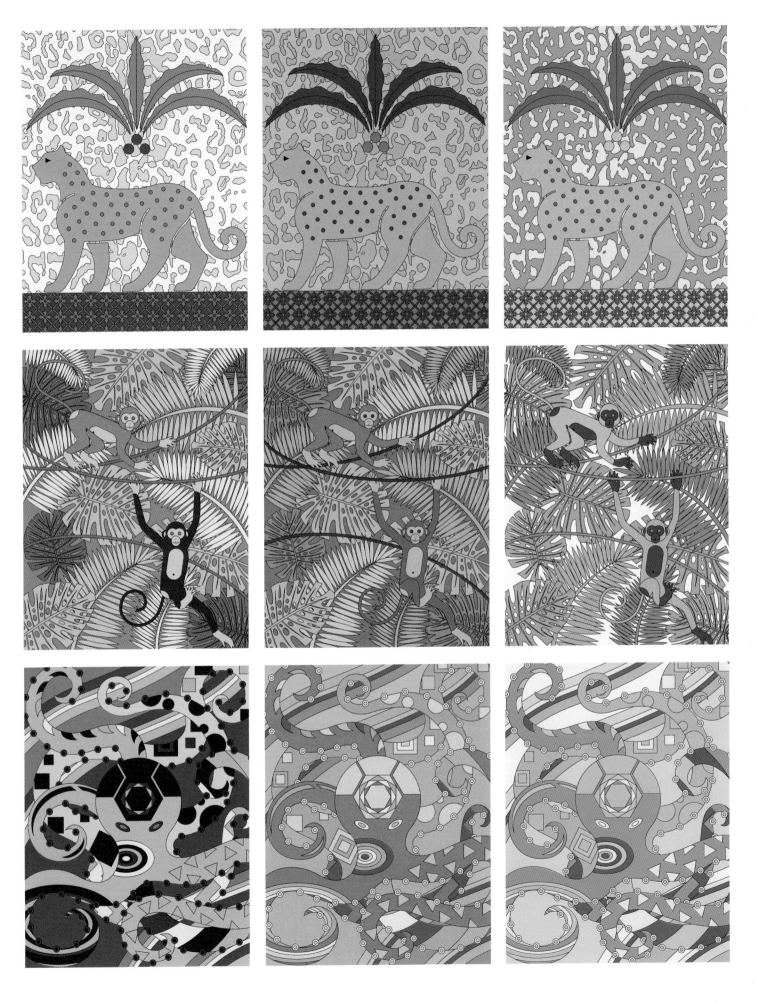

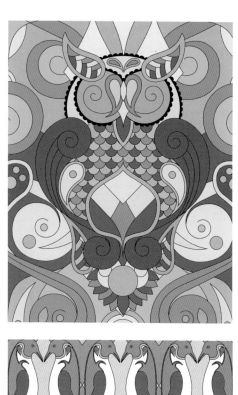
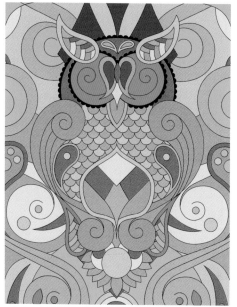
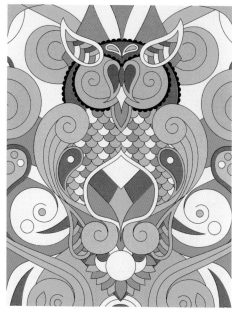
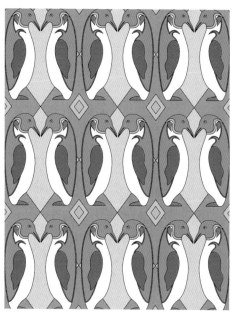
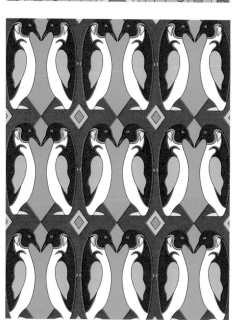
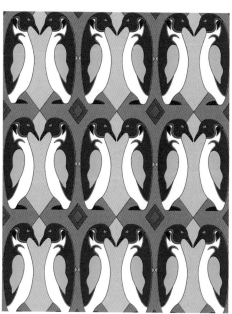
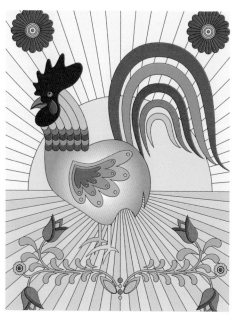
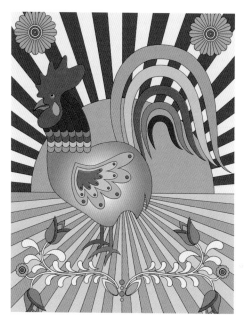
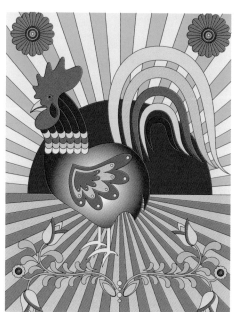

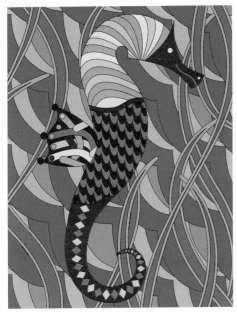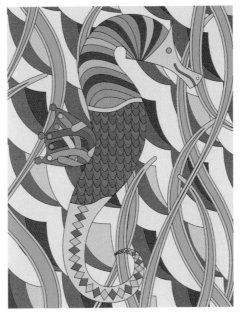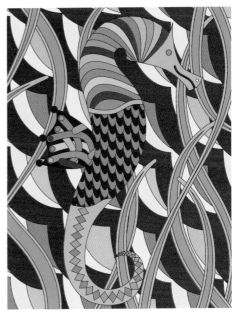
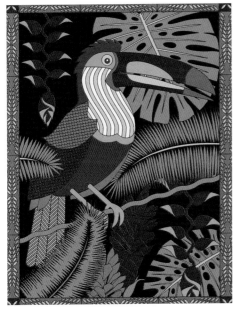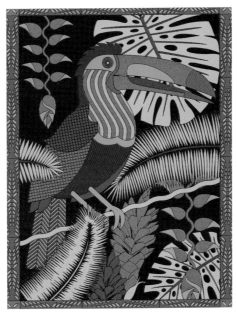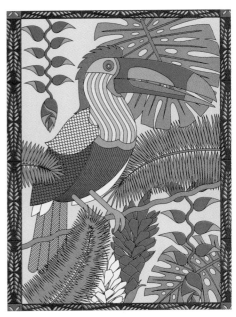
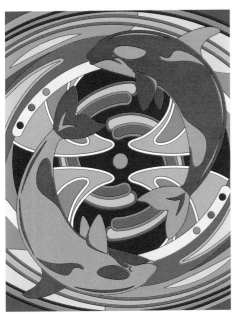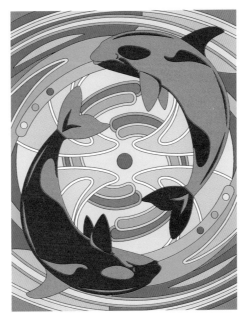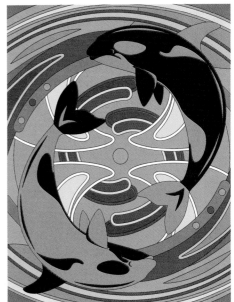

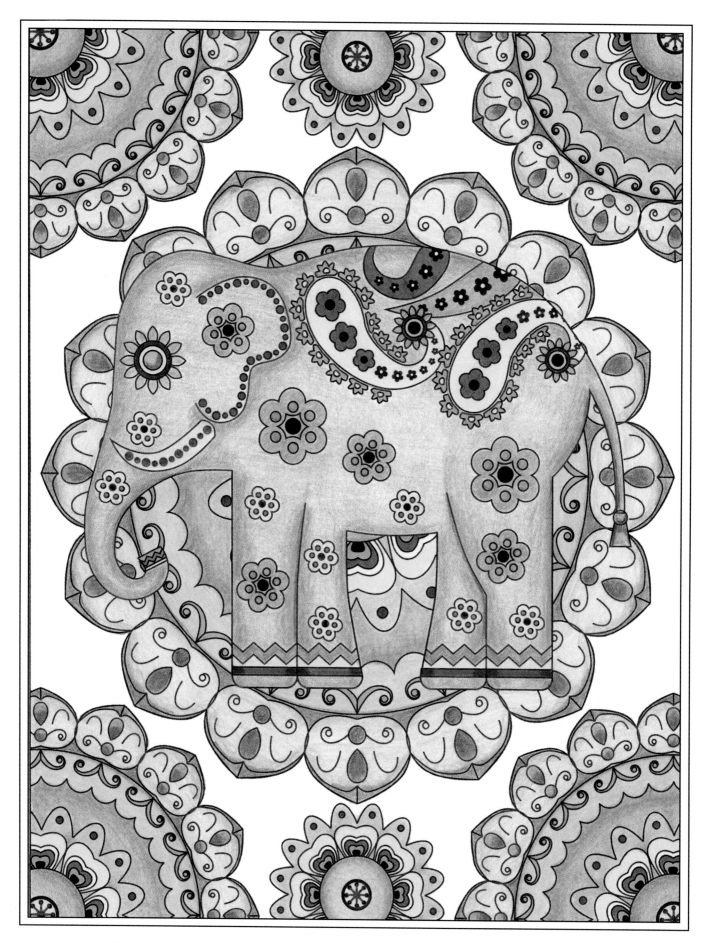

Colored pencils (Prismacolor), markers (Sharpie). Color by Darla Tjelmeland.

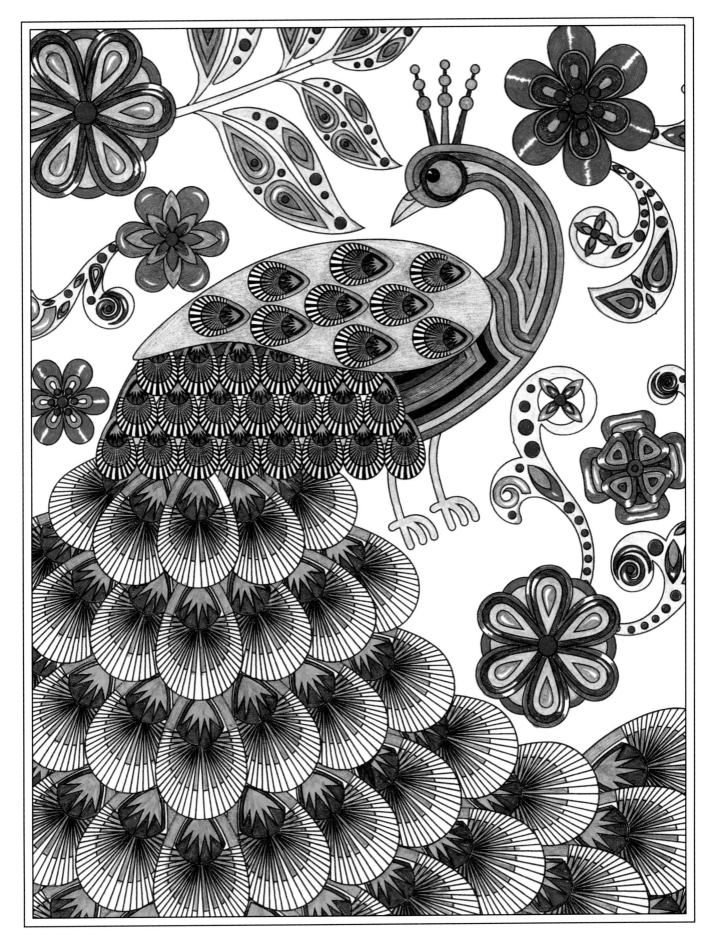

Colored pencils. Color by Elaine Sampson.

11

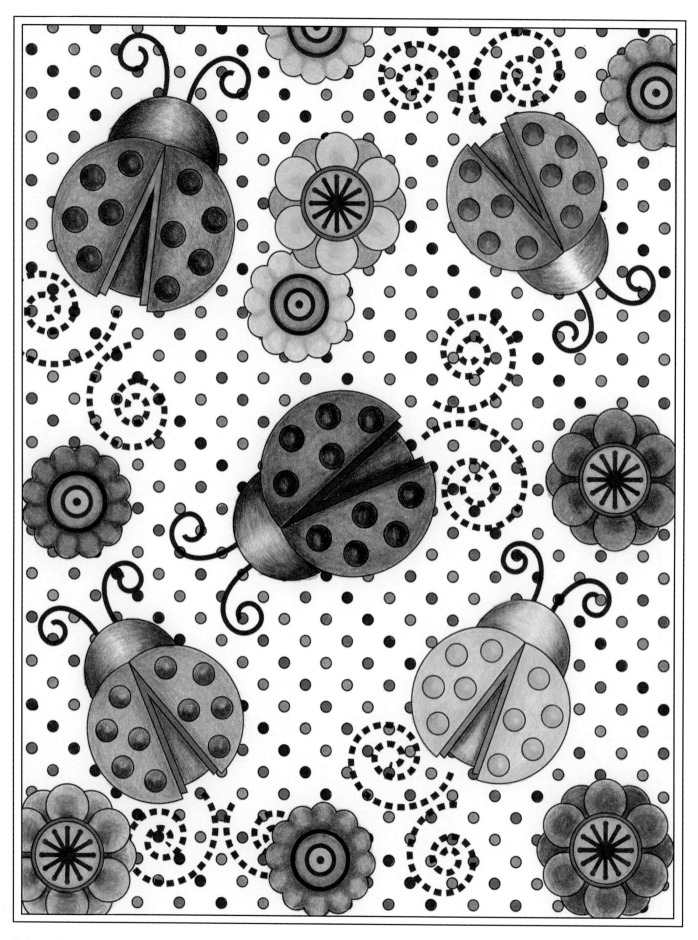

Colored pencils (Prismacolor), markers (Sharpie, Bic). Color by Darla Tjelmeland.

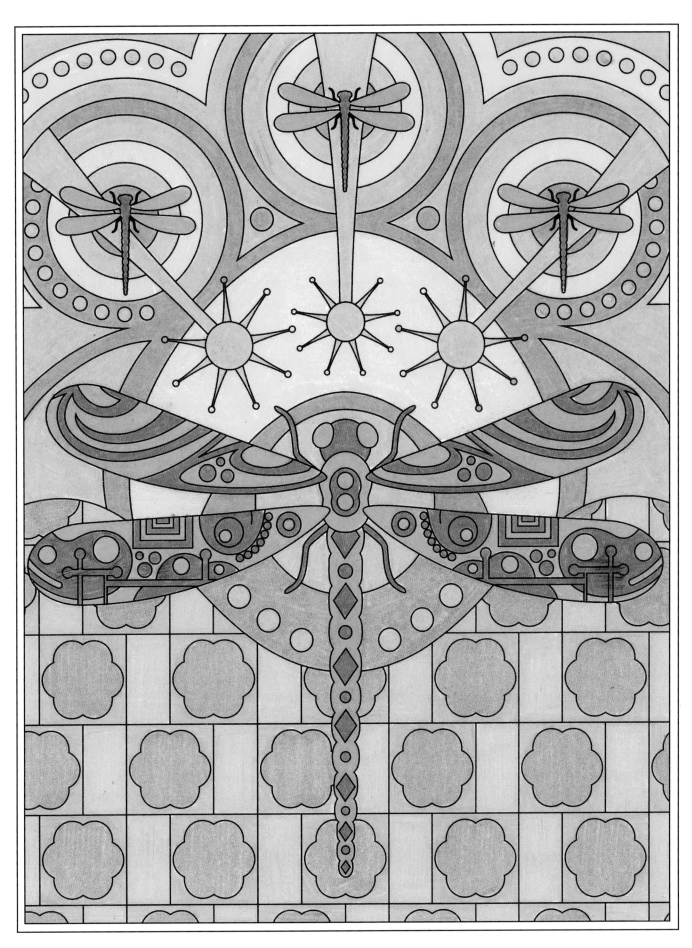

Colored pencils (Prismacolor). Color by Kati Erney.

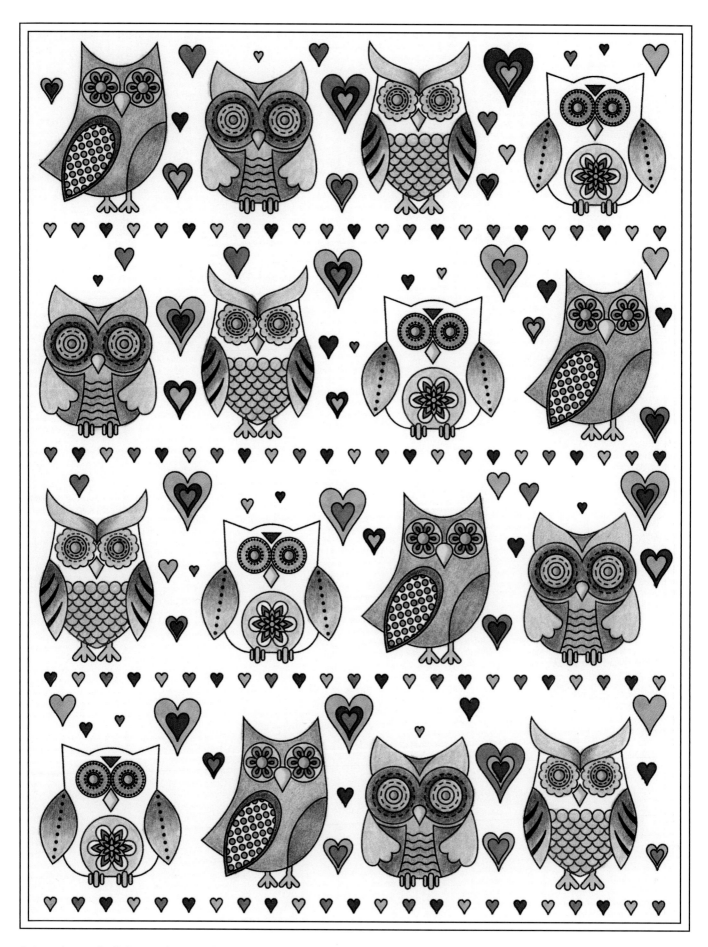

Colored pencils (Prismacolor), markers, blender. Color by Darla Tjelmeland.

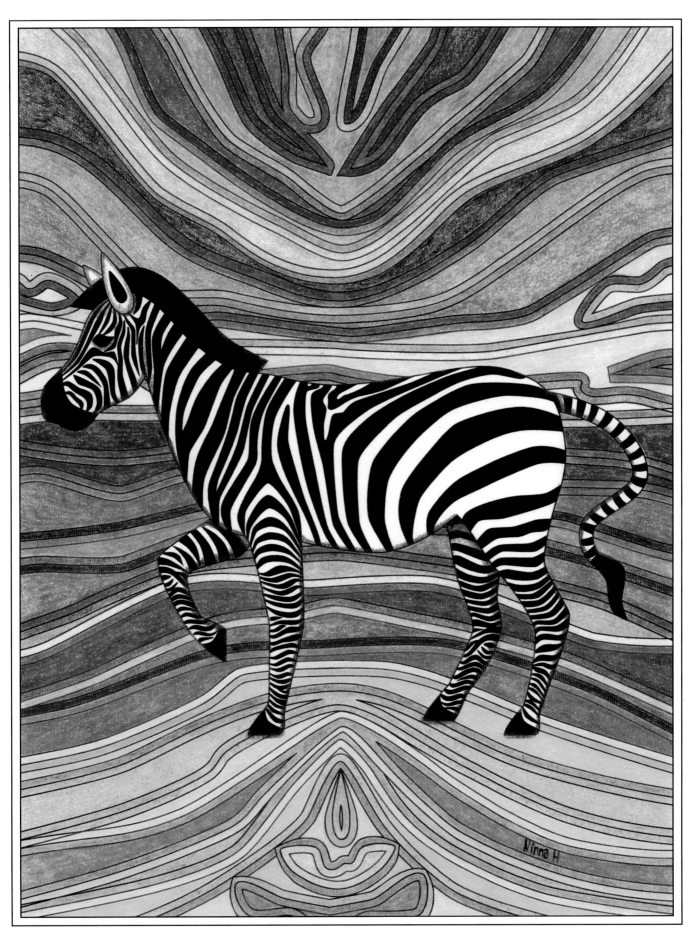

Colored pencils (Derwent Coloursoft Pencils, Faber-Castell Polychromos Color Pencils, Faber-Castell Art Grip Pencils).
Color by Ninna Hellman.

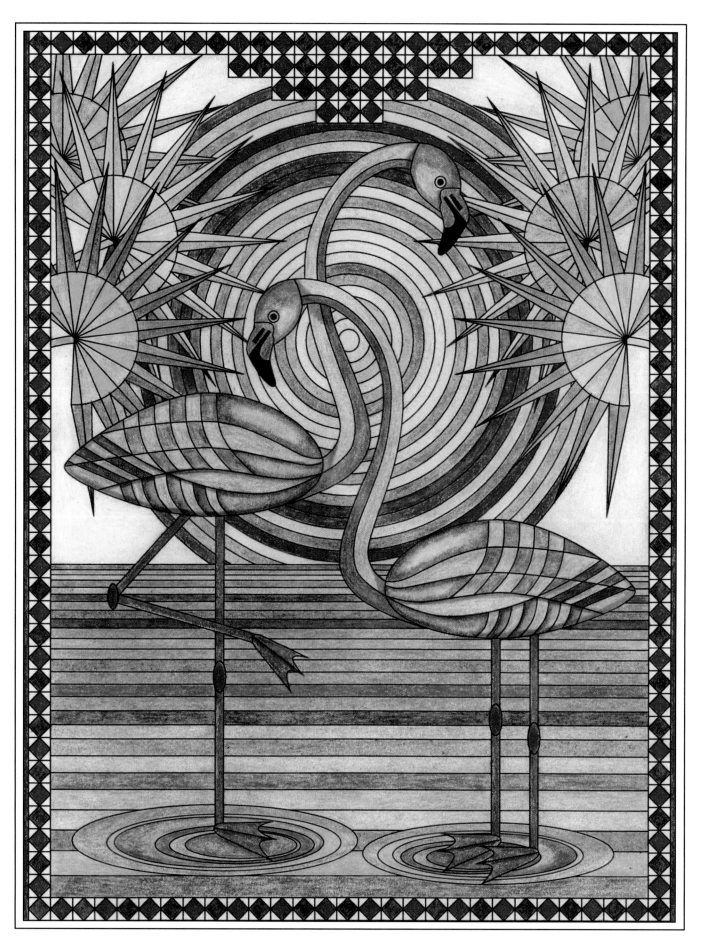

Colored pencils (Derwent Coloursoft Pencils, Faber-Castell Polychromos Color Pencils, Faber-Castell Art Grip Pencils).
Color by Ninna Hellman.

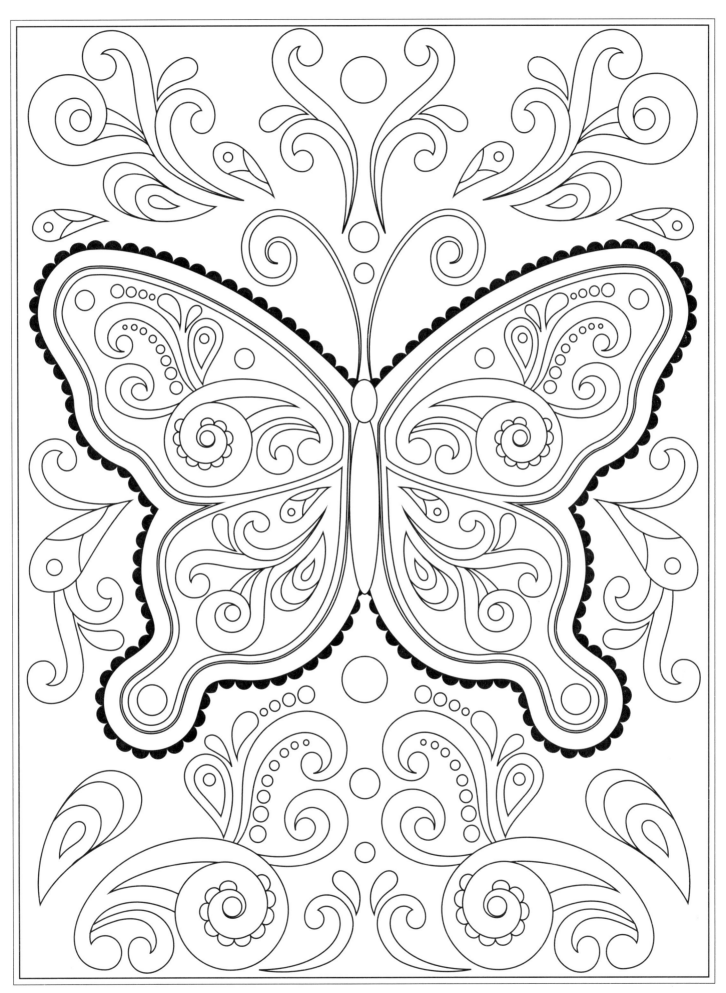

We delight in the beauty of the butterfly, but rarely admit the changes it has gone through to achieve that beauty.

—Maya Angelou

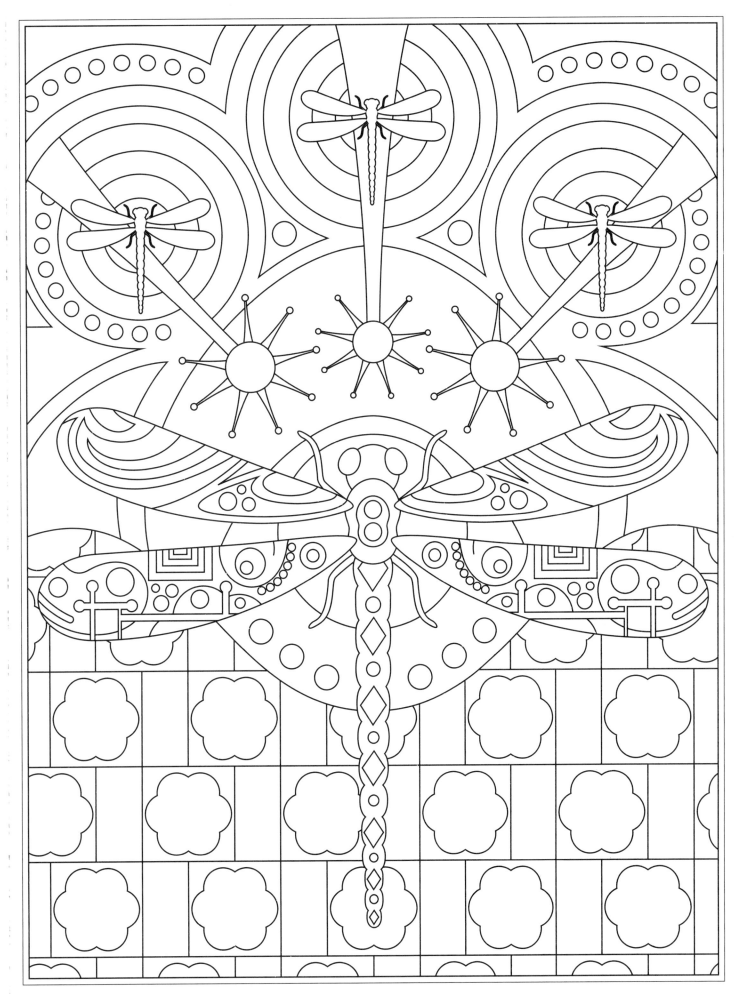

19

Realizing our true potential, in a
way that also benefits other
people, is the ultimate expression
of the power of the dragonfly.

—CHRIS LUTTICHAU, *ANIMAL SPIRIT GUIDES*

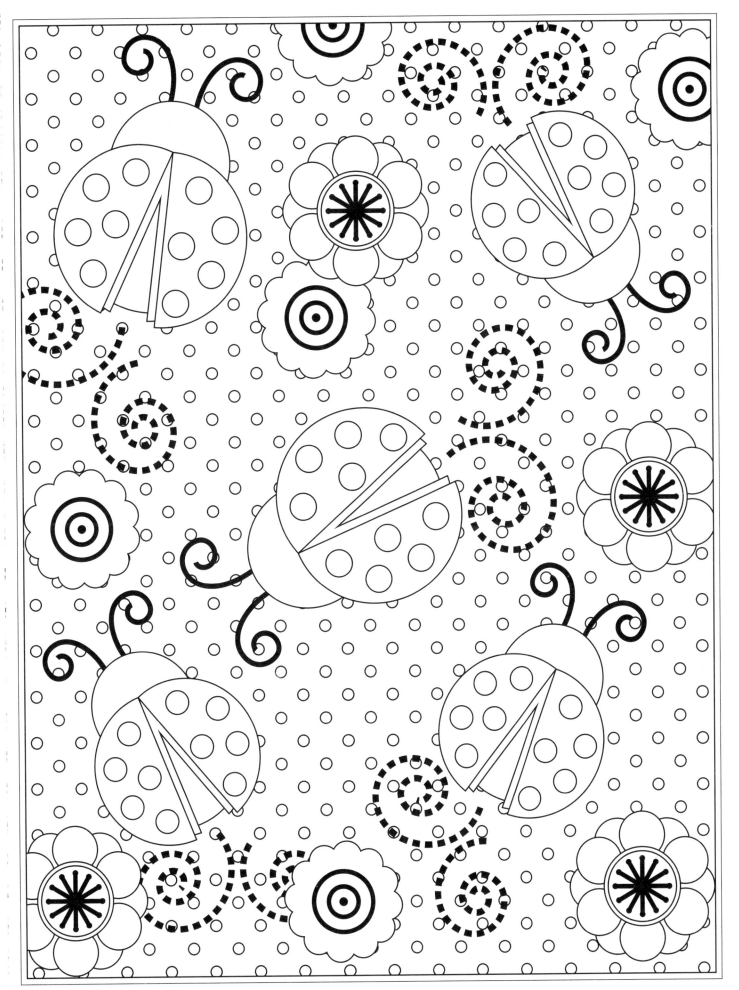

How brave a ladybug must be!
Each drop of rain is big as she.
Can you imagine what you'd do,
If raindrops fell as big as you?

—AILEEN FISHER

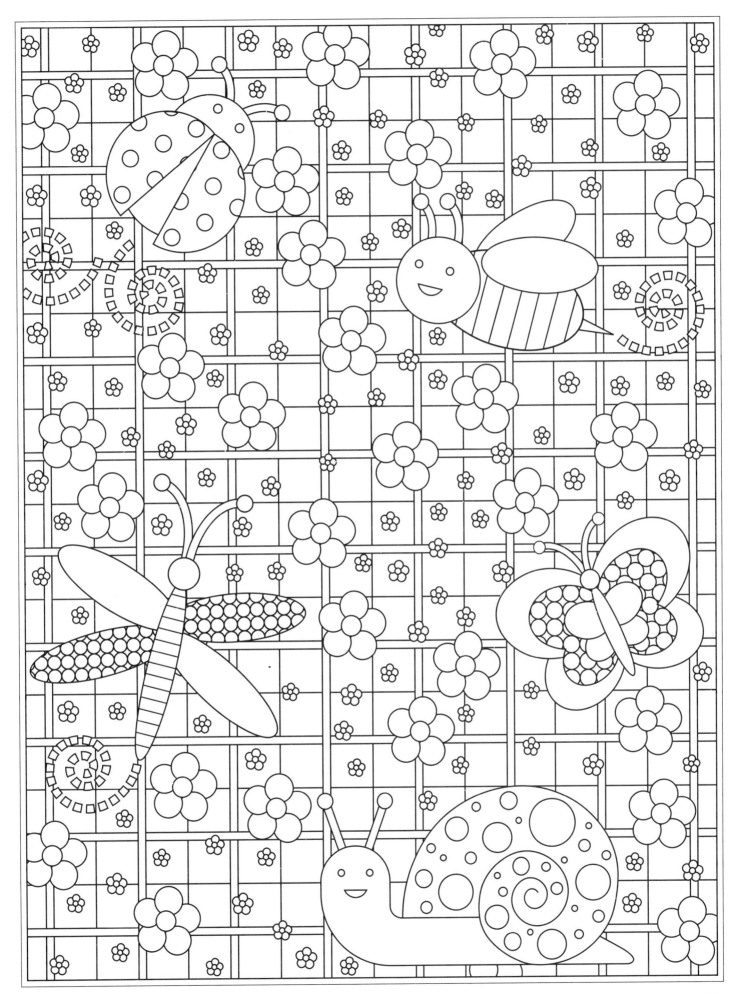

Together is a wonderful
place to be.

—Unknown

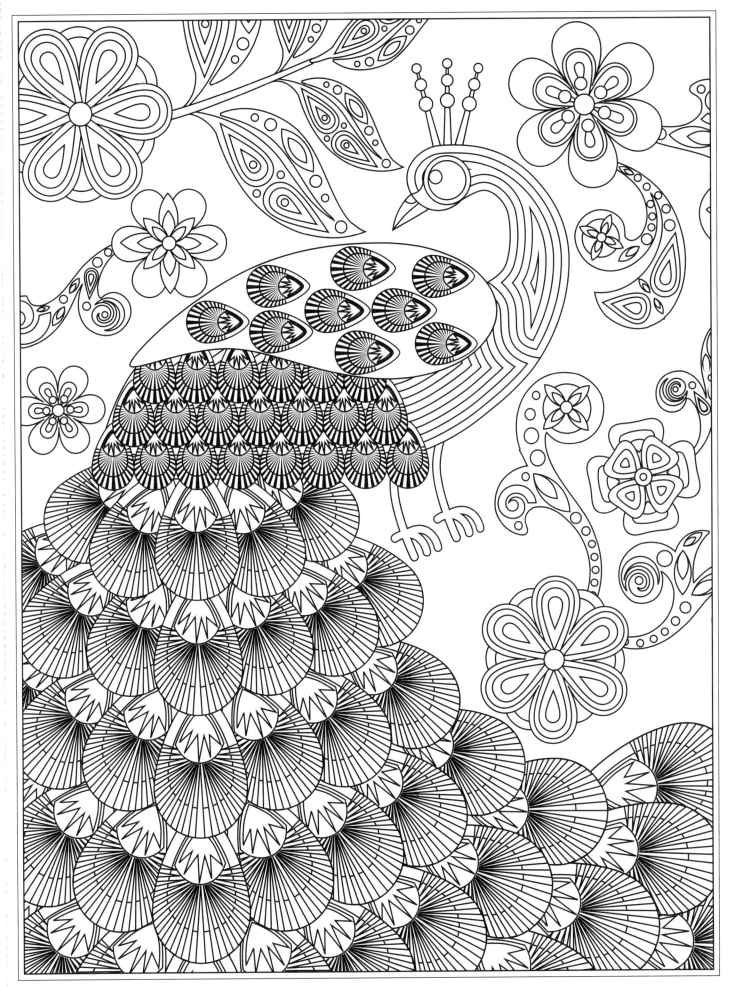

Do your darnedest in an
ostentatious manner all the time.

—GEORGE S. PATTON

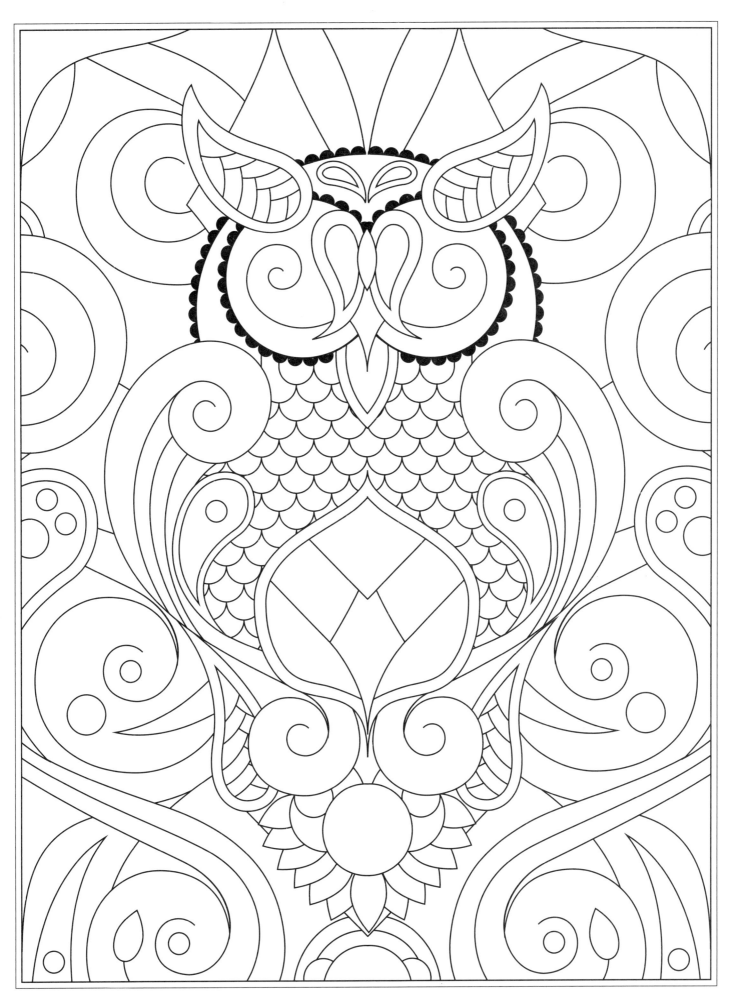

Never mistake knowledge for
wisdom. One helps you make
a living; the other helps you
make a life.

—Sandra Carey

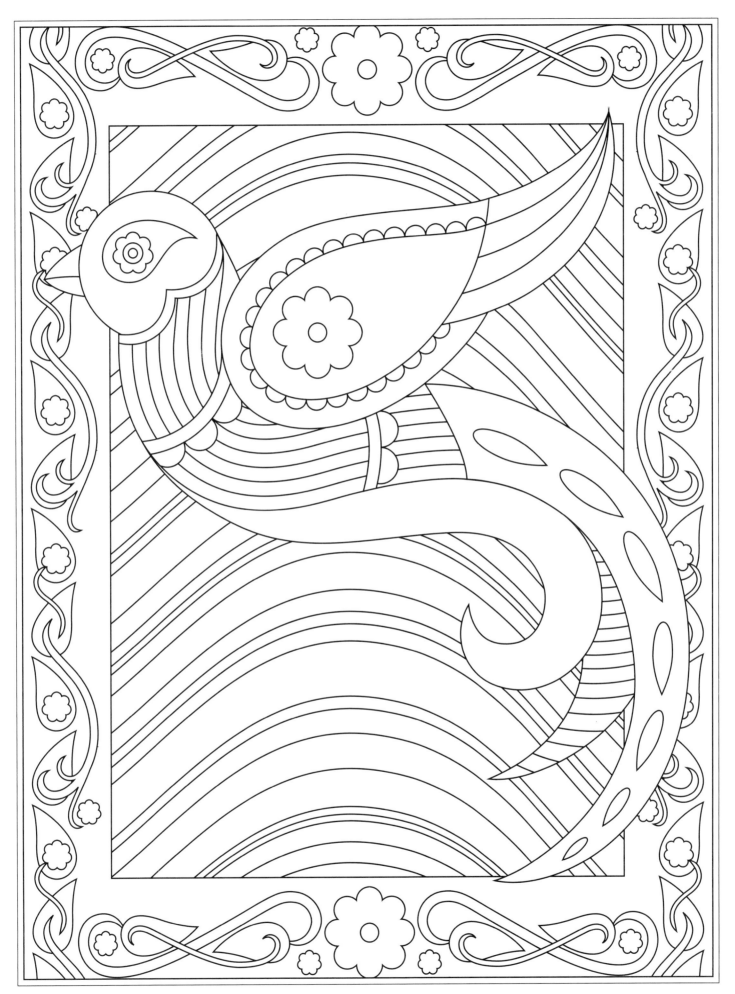

The sparrows jumped before
they knew how to fly, and they
learned to fly only because
they had jumped.

—LAUREN OLIVER

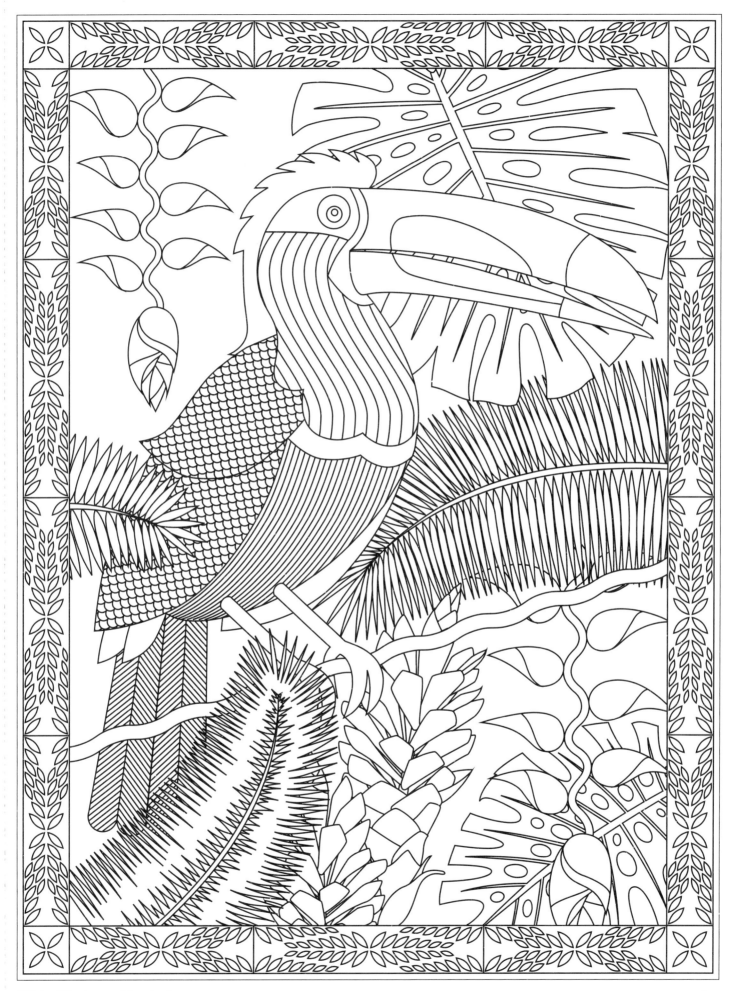

Be uniquely you. Stand out.
Shine. Be colorful. The world
needs your prismatic soul!

—AMY LEIGH MERCREE

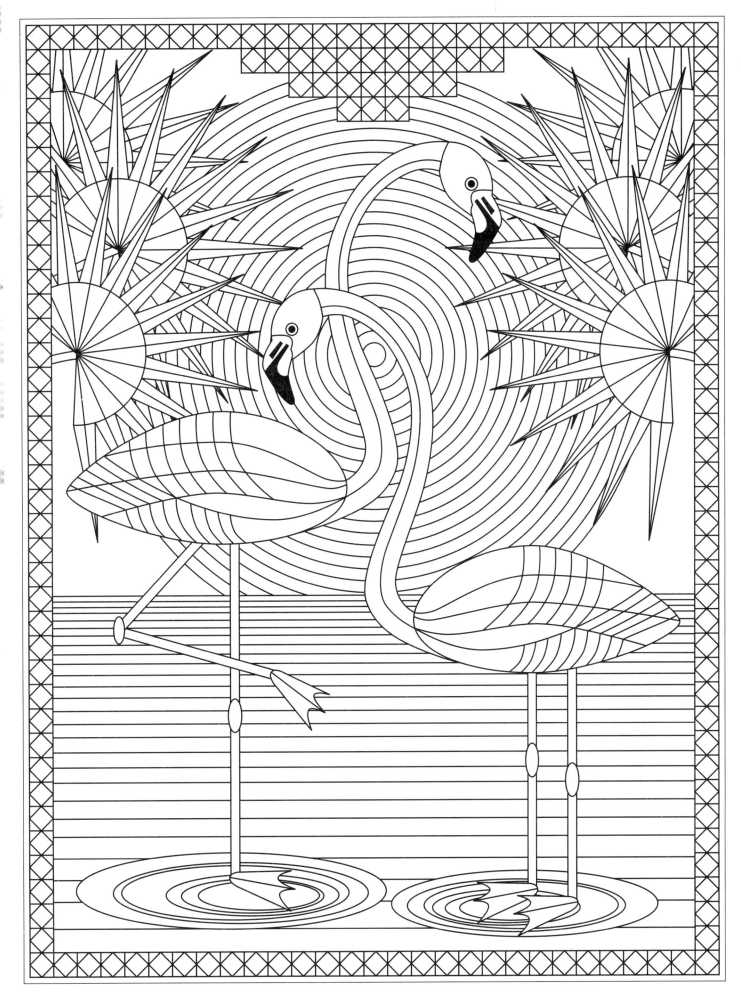

Stand tall, stand proud. Know
that you are unique and
magnificent. You do not need
the approval of others.

—Jonathan Lockwood Huie

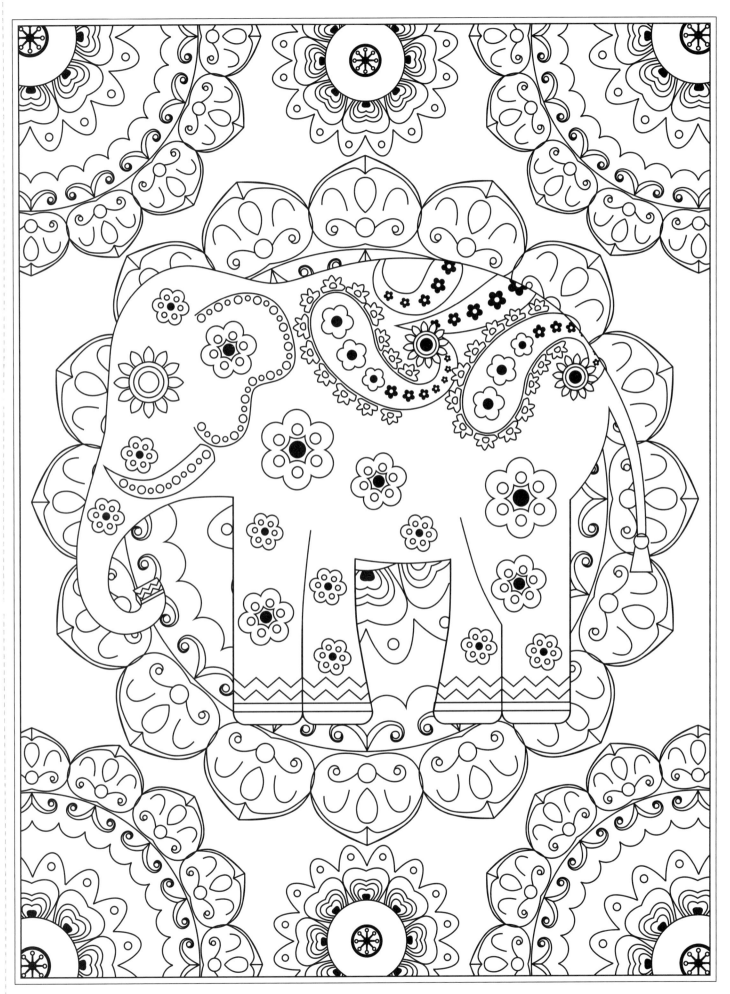

If you don't have a memory like
an elephant, then make an
impression like one.

—UNKNOWN

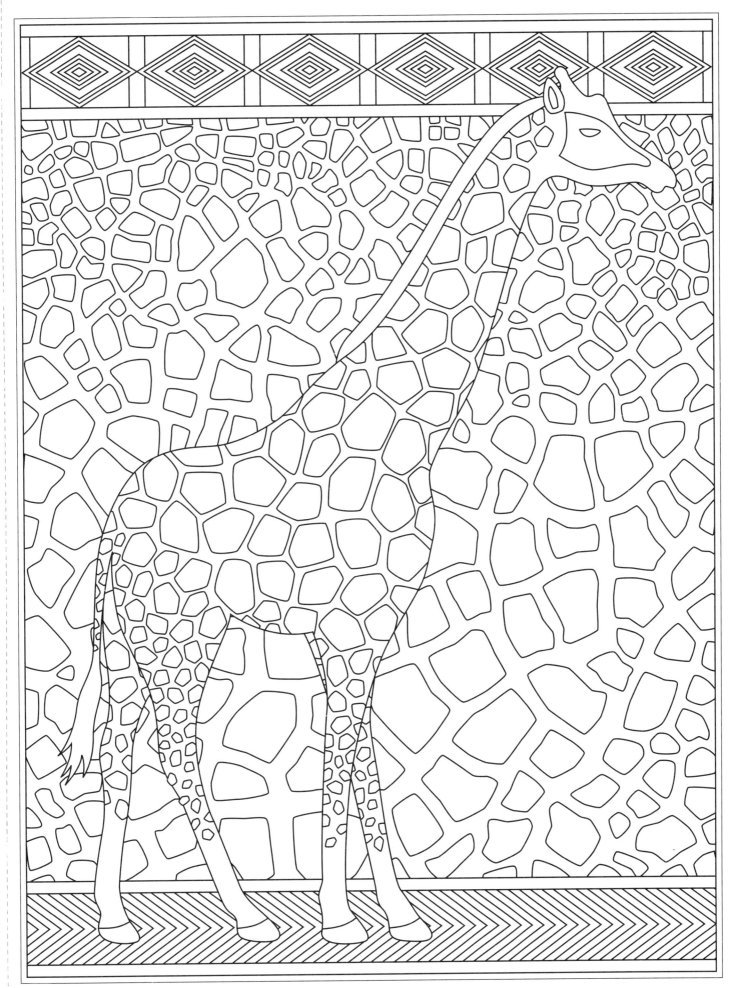

Stand tall.
Reach for new heights.
Don't be afraid to stick your neck out.
Preserve wild places.
Eat fresh greens.
Be head and shoulders above the rest.
Keep your chin up!

—ILAM SHAMIR, *ADVICE FROM A GIRAFFE*

Behold the Zebra on the plains, and shudder at his mighty manes!

—Ogden Nash, *The Zebra*

A leopard does not change his
spots, or change his feeling that
spots are rather a credit.

—Ivy Compton-Burnett

I learned the way a monkey
learns—by watching its parents.

—Prince Charles

Cows are amongst the gentlest of breathing creatures; none show more passionate tenderness to their young when deprived of them; and, in short, I am not ashamed to profess a deep love for these quiet creatures.

—Thomas De Quincey

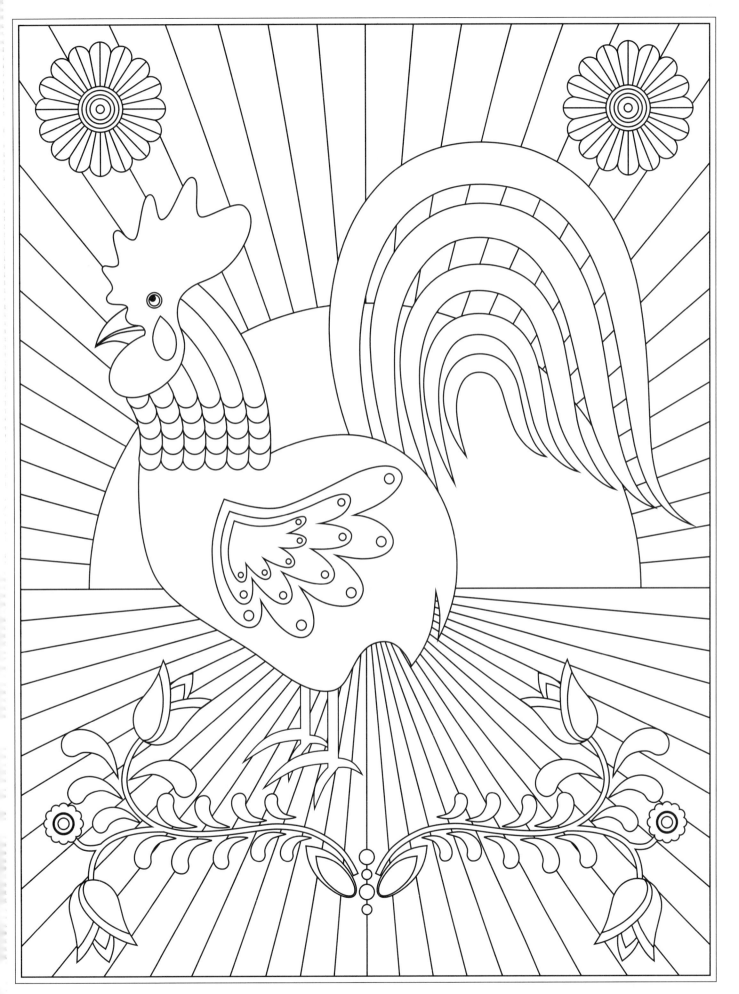

A rooster crows only when it sees the light. Put him in the dark and he'll never crow. I have seen the light and I'm crowing.

—MUHAMMAD ALI

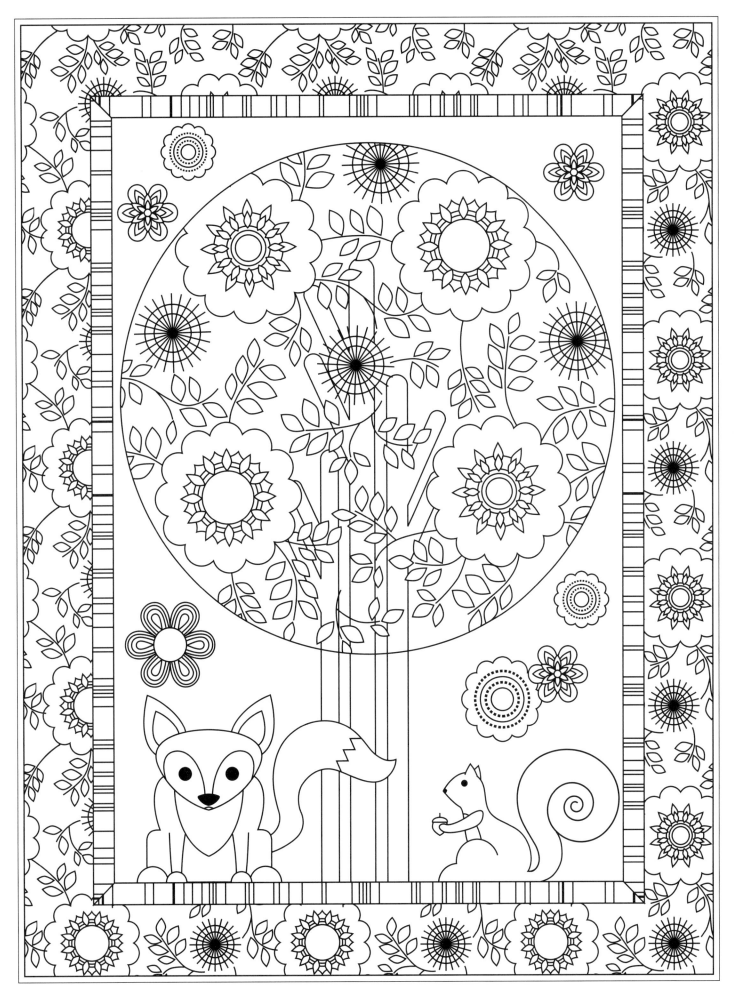

There are some woodland creatures that, no matter how many bread crumbs you leave out for them... no matter how patiently you wait... are never going to be yours. They'll never let themselves be tamed. Because they prefer to run wild and free in the forest.

—MEG CABOT

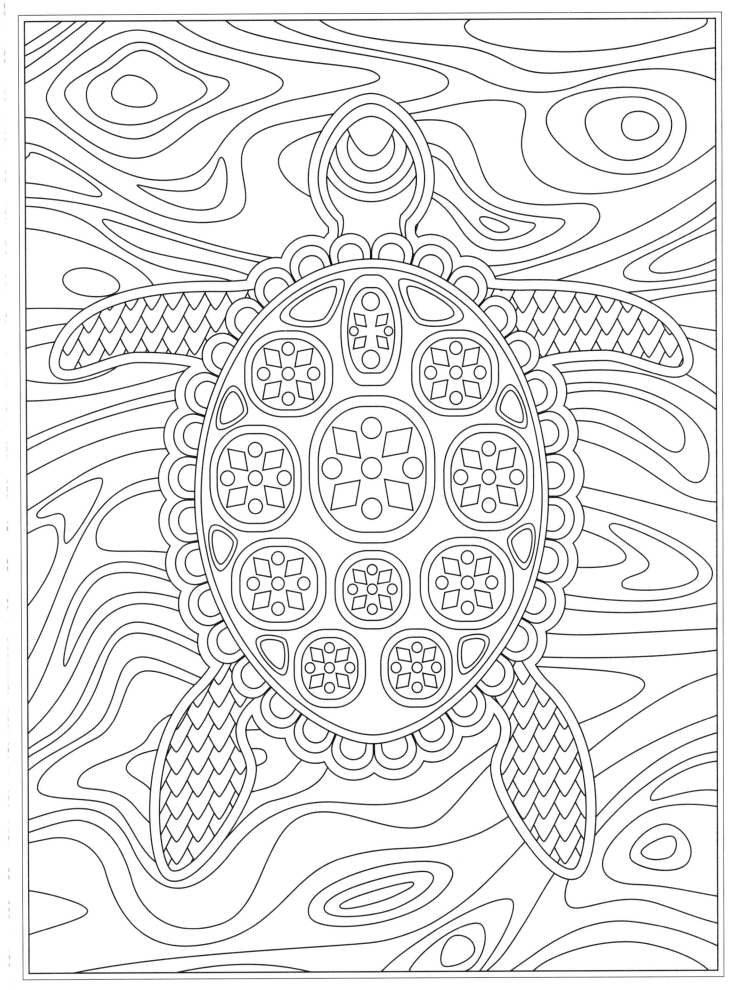

Take a walk with a turtle. And
behold the world in pause.

—Bruce Feiler

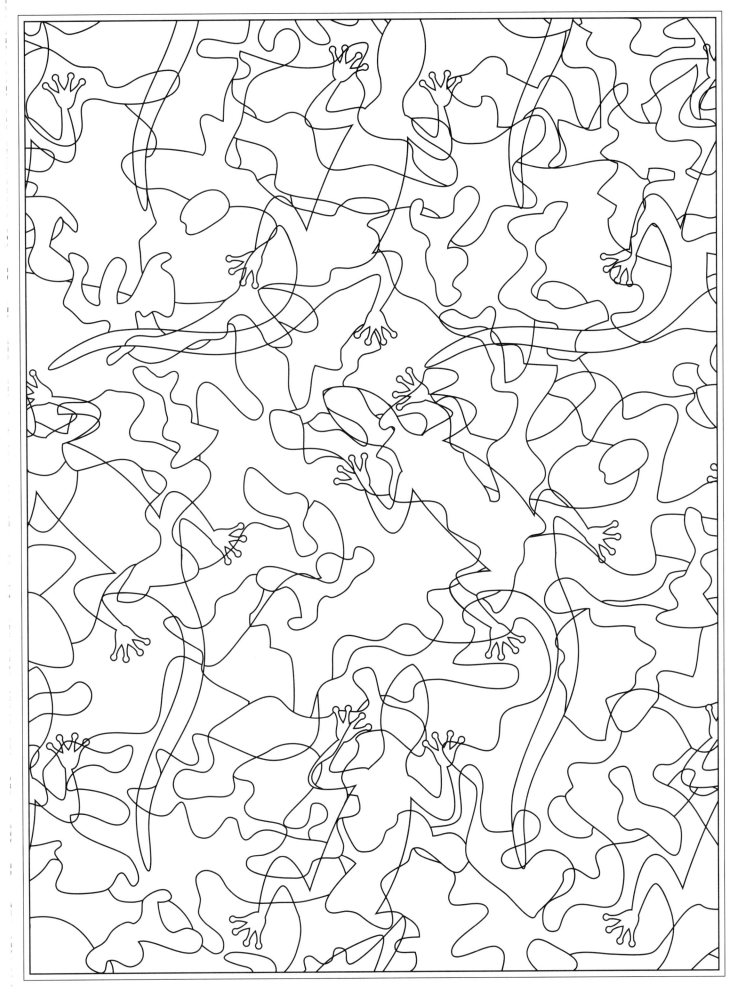

He viewed us, as we passed him by,
With calm and yet with questioning eye,
But moveless still, as though the stone
Were portion of his being's own.

—Edward Robeson Taylor, *A Lizard of the Petrified Forest*

The octopus moves skillfully in a realm that is in constant motion. Ever changing, shifting, and wafting in accordance with the pull of the moon, the octopus' depth of mystery is enhanced by its own environmental aura.

—Avia Venefica

To be a fish in the ocean
what would it be,
to swim throughout waters
so gracefully.
To see something so beautiful
that's always hidden away,
these wonders of the ocean
could be seen every day…

—ROBERT ARTHUR MILLER, *TO BE A FISH IN THE OCEAN*

Not all stars belong to the sky.

—Unknown

You cannot teach a crab
to walk straight.

—Aristophanes

See the seahorse in the sea.
Where else would the seahorse be?
For though it's dainty as a wish,
the seahorse is, you see, a fish.

—DAVID ELLIOT, *THE SEA HORSE*

Nothing will turn a man's home into a castle more quickly and effectively than a Dachshund.

—QUEEN VICTORIA

There's no need for a piece
of sculpture in a home that
has a cat.

—Wesley Bates

Butterflies can't see their wings.
They can't see how truly beautiful
they are, but everyone else can.
People are like that as well.

—Naya Rivera

A wise old owl sat on an oak;
The more he saw the less he spoke;
The less he spoke the more he heard;
Why aren't we like that wise old bird?

—Unknown

I realized that cats make a perfect audience: they don't laugh at you, they never contradict you, there's no need to impress them, and they won't divulge your secrets.

—ELLE NEWMARK, *THE BOOK OF UNHOLY MISCHIEF*

There is no faith which has never yet been broken, except that of a truly faithful dog.

—Konrad Lorenz

Is it not curious, that so vast a being as the whale should see the world through so small an eye, and hear the thunder through an ear which is smaller than a hare's?

—HERMAN MELVILLE, *MOBY DICK*

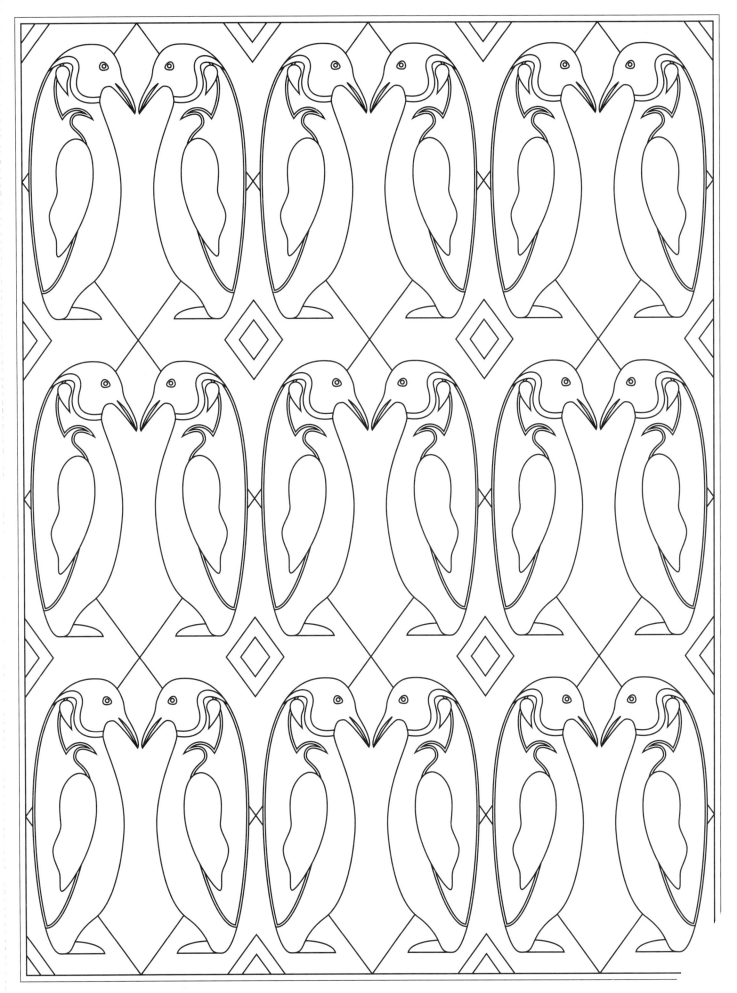

I've never been in love, but if a penguin can find a soul mate, I'm sure I can, too.

—Rebekah Crane, *Playing Nice*